**THE RENAISSANCE SOCIETY AT
THE UNIVERSITY OF CHICAGO**

MARCH 22–APRIL 26, 1992

WHY PAINT?

**JUDY
LEDGERWOOD**

**JIM
LUTES**

**KAY
ROSEN**

**KEVIN
WOLFF**

Acknowledgements

"Why Paint?" integrates The Renaissance Society's investigations of artistic concerns over the last two decades. It presents work which is conscious of the conceptual, language-based examinations of the 70s and 80s, while continuing the more personal expressions of mark-making. After a generation of artistic communication delivered with the rapidity of sound bites, this work halts us in our tracks, demanding not only our time but also a renewed commitment to looking.

Up front I would like to thank LaSalle National Bank, Chicago, for coming to our aid with underwriting for this catalogue. Their support enabled us to work closely with the artists at a crucial time, when the exhibition's concept was unfolding and its artworks were being selected.

We hasten to acknowledge Judy Ledgerwood, Jim Lutes, Kay Rosen, and Kevin Wolff, who gave so generously of their time, resources, and information to our staff. It was a privilege for all of us who had the pleasure to work with them.

We are grateful to David Pagel, art historian and critic from Los Angeles, for coming to Chicago to make studio visits and for developing an essay for this publication. We are grateful to David for his thoughtful insights and interpretations. In addition, we are grateful to art historian Craig Adcock, gallerist Carl Hammer, and art critic Kathryn Hixson for contributing their knowledge and resources to a lecture series that accompanied the exhibition.

We are especially grateful to John Vinci, architect and friend, for his assistance with the installation design; to Michael Glass and Michael Glass Design of Chicago for the excellence and generosity in their design work on the catalogue and invitation; to Paul Baker Typography of Evanston, Illinois, for their careful work with the typesetting; and to Meridian of East Greenwich, Rhode Island, for their production expertise.

This catalogue has been edited by Joseph Scanlan, The Society's assistant director, and I would like to thank him for the energy and high quality of work which he brought to this project.

Special thanks are extended to the staff of The Renaissance Society: to Thomas K. Ladd, Development Director; to Karen Reimer, Preparator; to Patricia A. Scott, Bookkeeper and Secretary; and to Paul Coffey, Steven Drake, and Kristine A. Veenstra, Gallery Assistants. Their personal interest and diligent work greatly strengthened the organization of the exhibition, the installation, and this publication.

We are appreciative of the cooperation and generosity of the lenders to the exhibition. They deserve special recognition for their support of the artists and for sharing their works with us and our audience.

As always, my deep appreciation and gratitude for their continuing support and trust go to the Board of Directors of The Renaissance Society. I hope the reader will take the time to look through the list of these outstanding individuals from the Chicago community who contribute so generously of their time, energy, and resources.

The exhibition and publication have been funded in part by generous grants from the Illinois Arts Council, a state agency; the CityArts Program of the Chicago Department of Cultural Affairs, a municipal agency; and by our membership. Generous support has also been received from The Elizabeth Firestone Graham Foundation. Private support has been received from Timothy and Suzette Flood, Daryl E. Gerber, Robert Dunn Glick, Sam and Blanche Koffler, Ruth Horwich, Henry S. Landan, Donna A. and Howard S. Stone, and Bryan Traubert and Penny Pritzker. The support of these agencies, foundations, and individuals has been vital and our gratitude is extended to them.

Susanne Ghez
Director

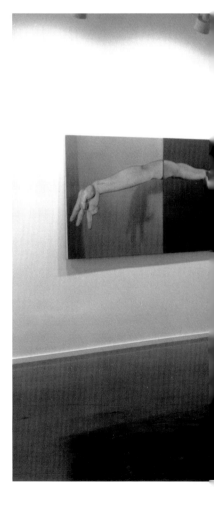

Why Paint?

"Why Paint?" reinvestigates, and reinvests in, the Modernist possibility that one's experience before a painting cannot be explained away by pre-existing theories. By means of overturned expectations, it engenders exactly that for which theory must account. While the exhibition as a whole departs from the Modernist notion that painting moves forward in a dialectical manner, subsuming and transforming the movements that preceded it, the show also distances itself from the superficial historicism that Post-modernism would put in the place of History. "Why Paint?" begins by asking an unanswerable question, and immediately proceeds to demonstrate the extraneousness of philosophical explanation.

One element of this perverse exhibition thus returns to the priority of the viewer's initially inarticulate experience before the object of art.

This is the experience that American Modernism once located at the center of its now almost unanimously derided, if equally misunderstood, approach to visual apprehension. For almost twenty-five years, this territory has been off limits to so-called serious criticism. Clement Greenberg and Michael Fried began their simultaneously supple and stubborn theories about the origins of artistic significance with the simple insistence that one pay focused attention to the physical effects of the individual painting before which one stood. However, their potentially open-ended exploration of the intersections between sensation and cognition — which was also a nuanced scrutiny of the ruptures between perception and conception — quickly got closed off in the cul-de-sac of inconsequence. This happened not when they claimed that

the experience intrinsic to Modernism's identity exists as an end in itself, as is often said, but when the question of its value got equated with the question of its very existence. In a strange way, and for reasons that have more to do with opportunistic careerism than intellectual rigor or visual acuity, the question of what one's aesthetic experience might count for was subsumed by the question of whether or not it even existed. Subtle distinctions, often hair-splitting differences, and excruciatingly rarefied gradations got reduced, in a brutal fashion, to questions with yes or no answers.

The infamous end of American Modernism was not caused by some inflexible logic internal to its supposedly self-sufficient formal system, as its after-the-fact detractors would have us believe. Its demise was caused by the dialogical relationship

Installation view, left to right: Kevin Wolff, *Gang Symbol,* 1992; Jim Lutes, *Wizened,* 1992; Kay Rosen, *The Ed Paintings: Surprise, Technical Difficulties, Sp-spit it out, Blanks (diptych),* and *Ex-Ed,* 1988

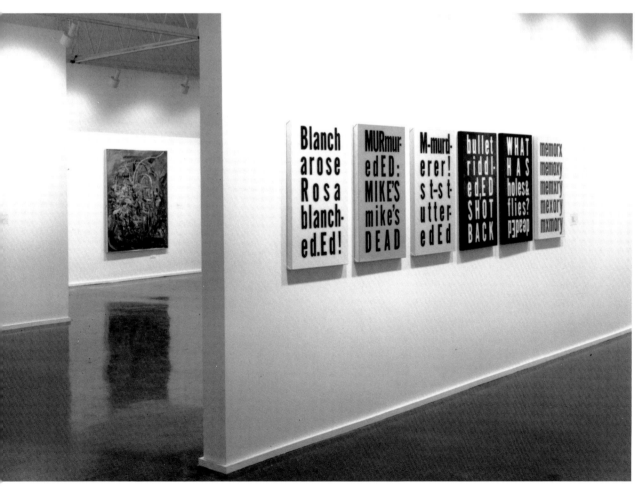

that took shape between those few who believed in the viability of extremely — perhaps excessively — individuated responses and those who argued that such refined self-reflection was nothing but self-deluded self-indulgence. A glimpse at Mikhail Bakhtin provides some insight into the context in which Modernism was transformed from a phenomenological inquiry into a mistakenly hollow ontology. In the early 1930s, Bakhtin wrote:

But no living word relates to its object in a singular *way: between the word and its object, between the word and the speaking subject, there exists an elastic environment of other, alien words about the same object, the same theme, and this is an environment that it is often difficult to penetrate. It is precisely in the process of living interaction with this specific environment that the word may be individualized and given stylistic shape.*

Indeed, any concrete discourse (utterance) finds the object at which it was directed already, as it were, overlain with qualifications, open to dispute, charged with value, already enveloped in an obscuring mist — or, on the contrary, by the "light" of alien words that have already been spoken about it. It is entangled, shot through with shared thoughts, points of view, alien value judgments and accents. The word, directed toward its object, enters a dialogically agitated and tension-filled environment of alien words, value judgments and accents, weaves in and out of complex inter-relationships, merges with some, recoils from others, intersects with yet a third group: and all this may crucially shape discourse, may leave a trace in all its semantic layers, may complicate its expression and influence its entire stylistic profile.

("Discourse in the Novel," *The Dialogic Imagination* (Austin, 1981), p. 276).

Bakhtin's model of the intrinsic difficulties in aligning one's intentions with legible references, and finding a place for both of these "objects" in a world of continually colliding symbols, provides a schematic and effective map of the troubled interrelationships among competing commitments, priorities, and positions. His outline remains the best available for discussing the ways in which

contemporary painting still bears the marks of Modernist theory and contention. If a cue can be taken from the social-minded contextualists who ruled out Modernism's doubts along with its certainties, then its chief proponents' increasingly shrill insistence upon "the purity of the medium" can be traced back to the actual, polarizing arguments that took place in the late 1960s and the early 1970s. Put bluntly, Modernism didn't peter out, spiral in upon itself until it disappeared, or grow so etiolated and attenuated in its increasingly refined formal adjustments and calibrations that it dissolved itself out of existence. It was killed.

Its celebrated death was part of the radical operation of cultural ground-clearing that began with Minimalism, continued with Conceptualism, and has been repeated, ad nauseam, by the various forms of glib historicism that have come to be known as Post-modernism. A tragic casualty of this cultural warfare — although not, by any means, an innocent bystander — was painting. That the refrain, "Painting is dead," began as an exuberant rallying cry for the potential embodied by new art forms and formats, rather than as any sort of elegiac mourning for the loss of the possibilities of the old media, suggests how dramatically and effectively the lines were drawn between so-called cultural conservatives (in a public debate, Fried was even called a fascist) and the new self-proclaimed aesthetic rebels who would have no truck with the elitism and privilege that was mistakenly taken to be intrinsic to painting's difficulty, its defiance of mass production, and the exacting demands it makes on one's eyes and one's mind by means of the time-consuming, one-on-one encounters required even to see it. The one-sidedness of the struggle marks it as a largely symbolic battle over the value of particular forms of art, one in which seemingly insignificant differences and barely discernible characteristics get exaggerated to proportions that appear comic to those involved in more practical struggles, in which mediation and compromise are the norm.

Because Greenberg and Fried addressed abstract painting more than any other art form and made it into the vehicle for an inimitable and quasi-religious experience found

nowhere else in the culture, it suffered more than a sort of guilt-by-association when Modernism was abolished. It became the scapegoat whose ceremonial disposal was meant to ensure the seriousness of the intermediary practices that bypassed ambiguity in favor of making more direct political statements. When the various strains of Post-modernism emerged in the 1970s, they denied painting's heterogeneity, multiplicity, and indeterminacy in order to argue that photography, performance, and text-based art were the true heirs to, or had a monopoly on, the very open-ended principles that were robbed from painting just as it was made over into a supposedly monolithic, authoritative, and exploitative art form.

If this rejection of Modernist abstraction did not consign every form of painting to the dust bin of history, it greatly reduced the chances that any version of this art would be taken seriously. Painting was, in the language that displaced it, Post-modernism's excluded "Other." It was aggressively buried by an ostensibly open and inclusive practice that, in the name of political expediency, dispensed with it wholesale in order to make a place for its own favored forms and artists in aesthetic discourse, as well as in galleries, museums, and private collections. As Freud has argued, and as feminism has demonstrated again and again, the repressed always returns, and usually in powerfully mutant forms, given to deceptive tricks and quietly disruptive practices that function according to one logic while masquerading as another. Because of necessity, contemporary painting has taken over indirection as its current modus operandi.

That the once volatile rallying cry, "Painting is dead," recently has become little more than a boring refrain substantiates not only the effectiveness with which this art was squelched — in that it's no longer necessary to reassert the obvious — but also suggests that interest in the critical reassessment of painting is under way. Few are satisfied with the alternatives: blind faith in the medium or utter rejection of its formal principles. Nevertheless, attempts to evaluate painting in the same terms that are regularly brought to bear on other art forms

Judy Ledgerwood, *Red Pine,* 1990, oil and encaustic on canvas, 90 x 144 inches

are immediately suspected of being thinly disguised marketing ploys. This fact demonstrates how entrenched the hostilities and prejudices against painting still are, despite being pathetically out-dated. The real danger implicit in the endeavor to interrogate painting is that the old terms will be disinterred and that the contemporary forms of this misunderstood art will be cast in terms nostalgic for a past that never existed, a past that was flattened into a stereotype when Modernism collided with a power-hungry movement that hid its blind ambition in a fraudulent populism.

According to the theories of Greenberg and Fried, art moves not with a lockstep progression of increasingly formalized refinements that ultimately approach some indefinable but undeniable "essence of art," but with unpredictability. It moves by means of the belief that everything artists inherit from history is fraudulent (or worse) and has to be reinvented, for the moment, with no guarantee that this can be achieved or that it will make sense, let alone that it might be communicated to a viewer. This radical doubt at the bottom of Modernism intimates that successful resolutions or even brilliant solutions do not endure past the moment of their performance. Modernism's detractors glossed over this moment of the movement's utter and essential negativity by reinscribing an overly rationalized form of "cultural criticism" in its place. The potential for meaninglessness, loss, and even sublimity was replaced by arrogant in-jokes known only to art world insiders, or sanctimonious demands more adequate for social work than aesthetics.

"Why Paint?" does not return to Modernism to revitalize the formal experiments that eventually dissipated into insipid exercises with spray cans and squeegees, but to play its unrelenting commitment to the present against Post-modernism's propensity to recycle every style that preceded the current moment. The exhibition intensifies Modernism's underlying incoherence and uncertainty by refusing to tie its radical displacements of rationality to formal specialization. And, unlike Post-modernism, it also refuses to disperse these fleeting glitches in sense across such a

vast array of possibilities that their force is diminished. What distinguishes "Why Paint?" from other contemporary exhibitions focused on the art of painting is its capacity to pull, from these normally opposed movements, exactly that which unsettles — that which is irrepressibly inventive, even original.

The stylistic diversity that immediately confronts the visitor to this exhibition is not a conventional demonstration of the myriad possibilities available to painters today, but a calculated arrangement designed to displace one's focus on formal coherence, or the continuity of genres, with an interrogation of the conceptual issues upon which contemporary painting has a determinate grip. The works of the four Chicago-based painters in the exhibition are united by how they give satisfying physical form to difficult ideas. None of the works here illustrates concepts, suggests possibilities, or exemplifies transcendent notions. Didacticism is not practiced. All of the disparate paintings work by showing, demonstrating, enacting, acting out, posing, and revealing — by performing real (if theatrical) functions in the elusive space where reality and illusionism meet. The works in "Why Paint?" refuse to be subordinated to supporting roles — or to rely on ulterior theories — in the same way that they refuse to be relegated to some harmless category of artistic autonomy, where their effects could more easily be shunned as merely decorative and their beauty could more readily be dismissed as formal stunts.

To this end, the exhibition cleverly addresses the fetishized distinction between abstraction and representation by ignoring the notion that "purity" somehow belongs to the former category any more than to the latter and by showing that abstraction can take as many forms as figuration. "Why Paint?" demonstrates that the question is not whether a painting falls into one group or the other, but whether it works in spite of its normal location. The exhibition's irreverent approach to conventional categories and traditional art historical genres matches its works' disregard for theory, their refusal to appeal to any external elements for their justification. Although all of the paintings are explicitly referential and

therefore at odds with Modernism's unrelenting desire to create, momentarily, the illusion of autonomy, they still maintain that movement's insistence on physical presence, on being able to grab one's eyeballs, arrest one's movements, and sustain one's gaze. The paintings in "Why Paint?" are strange hybrids of Modernist closure and Post-modern openness; they invite comparisons to the ordinary world of sensate experience and build narratives out of timely issues without diminishing their identities as works of art, as mute, formal structures with a primarily visual appeal. The exhibition brings together the work of four very different painters to make the point that what counts in this art has less to do with the oils, enamels, and acrylics that are applied by various means to flat surfaces than with what happens between these planes — between painter and painting, between a pair of canvases or a larger grouping of images, and, most important, between each painting and the individual viewer.

"Why Paint?" works by means of disruption, via defied expectations. It plays fast and loose — but not irresponsibly — with conventions and generalizations. The installation consistently and repeatedly promises to arrive at some form of coherence, nearly achieves this harmonious resolution, but then frustrates, almost maliciously — and certainly perversely — this desire for sense, closure, and comprehension. No matter how one rearranges or reconceives the paintings in the exhibition, there is always an odd artist out. If the opposition is between image and language, Kay Rosen's small enamels on canvas do not fit in with the other three; if it is some form of abstraction versus photo-derived realism, then Kevin Wolff's surgically precise figure paintings are the oddballs; if it is intellectual restraint against explosive expressionism, then Jim Lutes's hallucinatory stews of urban detritus and painterly codes stick out like a sore thumb; and if the close-up focus on details that grounds narratives gets pitted against the motionless serenity characteristic of iconic beauty, then Judy Ledgerwood's grand yet intimate landscapes are left out. The permutations seem, if not endless, at least more fecund than the idea that any of these painters

fits comfortably into established categories. The incommensurability between the specific paintings and the means available for discussing them is one of the most resonant subjects of the exhibition.

The strength of "Why Paint?" resides in this willingness to pit styles and procedures against one another; in this context, each painter's work seems less like an example of a genre or a certain kind of subject than a weirdly singular instance of something that this art has never confronted. The exhibition as a whole shows that painting's defining impulse is not to hide out in a sacrosanct sphere of arcane aesthetic refinement, but to use this space to engage the world of ordinary experience more effectively . It does not empty the illusionism intrinsic to images into a supposedly more grounded and less deceptive world of "reality," but plays both off against each other, in collisions that generate sparks, insights, even the capacity to inspire. Unforeseen juxtapositions and unpredictable similarities give "Why Paint?" the dissonance that the art of painting has sought at least since the beginning of Modernism. If the works in the exhibition are *united* by fragmentation, the surface of each painting is *interrupted* by elements of the same. These intrusive, incomplete elements do not disrupt the formal coherence of the paintings as much as they smuggle, into the images, extra-pictorial associations and implications that open them onto interpretations extending well beyond the boundaries of their deliberate compositions.

In Judy Ledgerwood's *Red Pine* (1990), a tiny pink rectangle hovers like a glitch in vision along the top edge of what seems to be a gorgeous twilight view of a single tree's dark silhouette set against a smoky, deep maroon sky. The artificially pink blip measures only about two inches on a side, but still manages to counterbalance the massive black tree situated near the painting's left edge and cropped by its top and bottom. A neat antinomy could be imagined: "abstract" form on one side, "representational" depiction on the other. The list of oppositions might multiply accordingly: culture versus nature, artifice versus reality, pure paint versus illusionism, miniaturization

versus actual scale, art versus life, and so on. But Ledgerwood's painting plays havoc with such simplifications. Neither element dominates the experience of *Red Pine*. The 7½ x 12-foot canvas gives the viewer plenty of room in which to get lost in the pleasurable reverie induced by illusionism; it only refuses this experience when one's eye meanders too near the little rectangle and is jolted out of a world of depiction and into the formal realm of abstract line, shape, and framing edge.

This paradigmatically Modernist acknowledgement of the picture-plane is not based, however, on the elimination of representation. Ledgerwood's painting orchestrates a kind of double-sided viewing, one in which the memory of the alternative version always lurks just beneath the surface of the one the viewer actively experiences. Ambiguity is not intensified as much as it is subverted: nothing about the painting is vague, fuzzy, or indeterminate. The experience, rather, is that of boldness, strength, and resolution. The so-called law of the excluded middle is itself excluded as Ledgerwood's painting engenders a heightened attention to nuance and delivers a split experience. Perception and cognition occupy the same plane, but never dovetail.

Neither the jagged shapes that define the tree nor the neatly geometric edges of the seemingly arbitrary, cosmetic-colored rectangle function as determinate "figures" because the painting's third element is not a proper "ground." The stability of the maroon field is more than suspicious. The abstract rectangle infects the whole painting with such a precarious formalism that the black area suddenly appears to be not a tree but a colorless rupture in an otherwise consistent color field. Its edges echo those of Clyfford Still's electrifying abstractions whose vertiginous passages aggressively overrun abstract painting's relation to nature by obliterating the possibility of identifiable references. Ledgerwood's work is both a concise history lesson and compelling painting. It surreptitiously traces the power of American abstraction back to nature, while reclaiming elements of both realms for its own purposes. Like her other, more abstract works, *Red Pine* creates a space where knowledge unfolds

slowly, always somewhat out of sync with experience, but never far from the physical pleasure implicit in catching a glimpse of a bigger picture.

In Kevin Wolff's singular diptychs, human limbs and digits punctuate squeaky clean fields of softly diffused light. These exquisitely rendered arms, hands, and fingers fuse the fleshy solidity of figurative realism with the inanimate perfection that was once the provenance of still life painting, but lately has become the almost exclusive property of photography. Wolff's paintings unsettle because they side-step the tendency to treat the history of image-making as a carefree parade of styles available for easy appropriation and quick disposal. They return to painterly techniques and procedures that had vanished in the past, not to evoke their nostalgic grandeur, but to elicit their effects in the present. The initial appeal of his paintings is nothing if not visceral. Wolff's images impress a palpable violence upon their viewers. From across the gallery, they have the creepy fascination of severed limbs, not exactly the double-sided sense of attraction and repulsion that irresistibly draws us to regard horrific accidents and gut-wrenching mishaps, but a sensation not too distant from the irrepressible curiosity that pits our eyes against our minds in a tug-of-war that the body almost always wins.

Wolff's uncanny paintings examine the discrepancy between seeing and knowing to suggest that the religious dictum, "The spirit is willing but the flesh is weak," actually gets things backwards. His paintings show that this inherited wisdom is an illusion perpetrated by the mind in its attempt to control the body's impulsive desire to know the world in a manner more gripping than abstract thinking permits. Wolff's figurative still lifes do not simply invert the church's mind/body dualism, but describe, with complex clarity, the territory where corporeality and thinking intermingle. They never suggest that knowledge is exclusively constituted by the repression of base drives or that unmitigated sensations deliver us to the truth. The initial shock of seeing his images of disembodied limbs is soon undermined by the feeling that these forms are not sections of a severed

anatomy, but elements of a vital substance animated by a consciousness all its own.

Two of Wolff's paintings intimate that parts of the body have taken a break from their everyday, unthinking, manual activities to regard themselves in a mirror. *Pointing Arm* (1990) has the presence of a fugitive arm that has momentarily distanced itself from the body to which it belongs (only the shadow of the figure's head is visible). The autonomous arm points an accusatory finger at itself, half in the spirit of self-indictment and half with the thrill of being able to do so. It is as if Wolff has caught a self-conscious and self-critical limb reflecting about itself as it is doubly reflected back to the viewer in the shape of the letter "u." As a metaphor for the activity of painting and viewing, *Pointing Arm* charges the empty space between its two illusionistic index fingers with an energy that seems to be brought forth from nothing. In *Curled Finger* (1992), a single index finger inches forward, like a frightened, sluggish organism, around the corner of a mirror. As if to confirm the substantiality of this surrogate picture plane, it presses its tip against the surface of the glass. In Wolff's painting, a tactile confirmation yields a visual doubling. Two knuckles are barely visible behind the sharp line that defines the edge of the mirror and divides the canvas in half, suggesting the presence of an invisible reality blocked out by the micro-drama on the painting's thin surface.

These two works displace the history of Modernist painting onto parts of the body. The hands stand in, metaphorically, for an intensely self-regarding art, one that has lost the capacity to depict the body as a unified and conscious entity, but hasn't lost the desire to discover new ways of reclaiming this power for itself. In the same way that Ledgerwood's paintings return to art history to deflect, in the present, its direction toward reductivism, Wolff's compelling yet funny pictures employ mirrors to trick painting, illusionism, and the viewer into relationships long absent from this art.

If the collision between words and images — or theories and paintings — produced an art predicated on the exclusion of narrative, and a criti-

cism devoid of ambiguity, then Kay Rosen's small-scale paintings re-enact this accident by playing the precise nature of linguistics against the physical pleasures of abstraction. Her slightly larger than page-size enamels on canvas inject a powerfully subversive sense of humor into a dialogue that has grown stale in its entrenchment. Rosen's image-less pictures use fragments of language to perform functions that run against the logic of reading. Some work like paintings in that they treat symbols physically, not as arbitrary markings that represent invisible sounds, but as pictorial elements whose relationships to color, edge, shape, and scale determine their meaning. But meaning, in Rosen's romp through sense and its opposite, is never determinate. References multiply, but are also blocked; complex mirror relationships are set up and then undermined; significance is hinted at and then driven home, or swallowed up by a black blank that tells us nothing except that something essential is missing or that something else has gotten in the way. In other words, meaning's ungovernability is the subject of Rosen's deceptively simple art. Broken rules, confounding parallel relationships, and puns make up the details of her conflations of verbal and visual significance. Her paintings slip through the seams of systematic attempts to prevent meaning from careening out of control. They don't quite succumb to the cacophonous babble that underlies — and is repressed by — language's rational organization as much as they give form to the befuddling excesses of this highly ordered, but no less open, system. Rosen's dismembered words and reconfigured phrases tweak meaning out of the smallest units of signification by disrupting the smooth transactions between our conventional expectations and the alphabet.

Like all her compressed visual poems, *Tree Lined Street* (1989) works more than one way at once. It inserts itself into the space between the words one reads and the stereotypical images they evoke in one's mind. This painting does not function like language: it refuses to become invisible once it conveys its message. Unlike the page of a text, this black-on-white canvas transforms the phrase it bears into a clever acknowl-

edgement of the picture plane's framing edges. Its left and right margins partially crop the first and last letters of "lined" and eliminate the first and last letters of "street." This physical manipulation suggests that the missing letters are shaded from view by two lines of trees on the left and right sides of the vertically oriented canvas. Rosen's painting complicates this reading's literalism by repeating this effect along its horizontal edges. When "street" loses its first and last letters, "tree" is spelled out. The phrase that constitutes the painting thus ends, in a self-referential but not circular fashion, precisely where it began. The doubled word "tree" suggests that the street runs horizontally, that the trees align with their representation in language, and that they line the image's top and bottom edges. By playing meaning and reading against vision, Rosen's painting thus intercepts the swift movement from perception to cognition. Her art literally and figuratively turns phrases around on themselves so that they always mean something else, as well as what they initially signified.

Another painting, titled *t-h-w-a-r-t* (1989), also puts a spin on the differences between images and words. It does what it says — and more — by dramatically slowing down and even detouring the process of reading. By phonetically spelling out its title, this painting mimics the activity that transpires when a viewer scans an unfamiliar image and attempts to discern the codes that might make sense of it. Standing before *t-h-w-a-r-t* and trying to decipher its message makes one feel slow, if not dumb. The writing looks like it has something to do with teaching art, but makes the viewer feel that it is he or she who needs the teaching, as if one were just learning how to read and had to laboriously sound out each syllable. Rosen's painting is instructive in its demonstration (and undermining) of the rapid pace at which we race through galleries in search of right answers and bottom lines. Located at the crossroads of cognition and sensation, her words return to painting to make a joke of the notion that language is a substitute for images or that either form is any more trustworthy than the other.

The elements that swim in and out of focus to form the congealing and dissolving, coagulating and dissipating

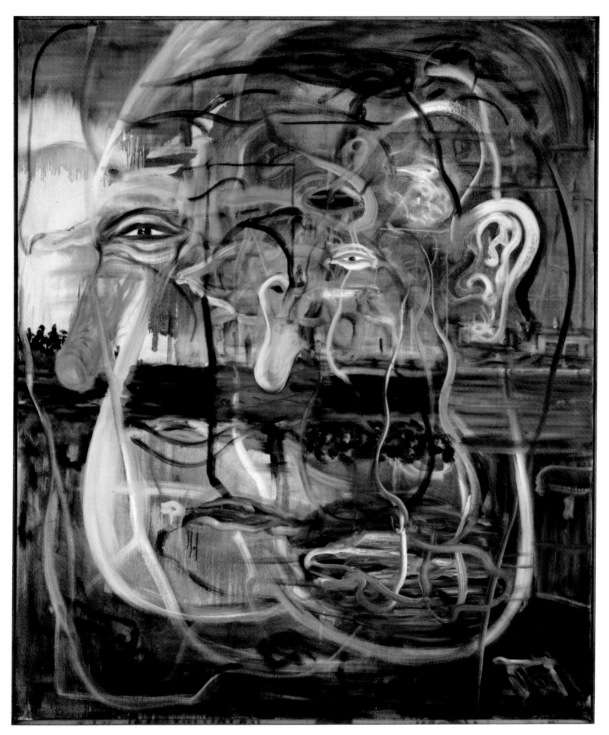

Jim Lutes, *Road Conditions,* 1992, oil on linen, 72 x 60 inches

surfaces of Jim Lutes's paintings often do not hold together long enough to constitute proper fragments. The brushstrokes, themselves, do not seem able to muster enough energy or conviction to claim that they represent singular artistic gestures. For that matter, it does not seem possible to describe the trails, smears, smudges, blots, and impure mixtures of oil and acrylic that cover Lutes's once clean linens as mistakes or failures. None of the myriad marks that make up any of his mid-size images embodies the self-satisfied confidence that always accompanies cynical dismissals of reference's potential, or smug "critiques" of non-representational painting's supposedly outdated promises.

Lutes's paintings occupy the netherworld between intention and accident, spontaneity and formula. They take their place on the perplexing terrain where the formal differences between abstraction and figuration give shape to distinctions between sincerity and disingenuousness. Here, where established forms no longer bear sustainable relations to the meanings that once were intrinsic to them, Lutes manipulates everything at his disposal to keep despair at arm's length. Occasionally, and always without warning, flashes of clarity manifest themselves among the debris that seems to overflow his paintings. In his ever-evolving whirlpools of stagnation, naivete and experience become indistinguishable, sometimes segue into wisdom, but always maintain their defiance of the implacable ordinariness of the everyday.

Road Conditions (1992) gives physical form to the conflict between one's bad habits and one's desire for change. In this uneasy picture, a man's translucent head floats over a crudely painted landscape. The ghostly figure's visage shares an eye with what could be another figure or might just be a mess. Their chins, or his double chin, mutates into a fat buttocks, one cheek of which also functions as a huge scrotum that dwarfs a pendulous smear of fleshy pink paint that is both a penis and a nose. Lutes's disturbing painting is almost graceful in its ugliness. None of the simplistic equivalences it sets up seems forced. As a whole, the work matter-of-factly instantiates the feeling of futility that comes with the knowledge that it is pointless to go on, but worse not to.

Hopeful Board (1991) dissolves the specificity of the malaise-infected defiance of *Road Conditions* in a more abstract maelstrom. For all its bright colors and aimless gestures, Lutes's painting is quietly terrifying: it would be lyrical if its loose freedom were not experienced as a groundless drifting, dissolution, or torpor. Its form recalls the format of *Road Conditions*, whose repulsive but identifiable organs and orifices at least anchor the painting — and the viewer — in a recognizable world. In *Hopeful Board* the landscape is there, but in a more ambiguous form. So is the figure, but much less as a depiction and more as a memory, or a nightmare, or just another confrontation with an inconceivable world and an unknowable future. The only identifiable object is a board that angles up from the bottom right of the image, protruding illusionistically from the painting. Lutes's picture suggests that this nondescript board might be one's last connection to a world riddled with insanity, wholly shot through with paranoia and dread. Far from being an intrusive element that disrupts an otherwise coherent surface, this common object appears as the last foothold in a world that is falling apart. Like Lutes's other paintings, *Hopeful Board* refrains from stating this fact but stutters and mumbles and otherwise gives inarticulate form to unspeakable breakdown and dissipation. Like the other three artists' paintings, Lutes's demonstrate that the question, "Why Paint?", comes both too late and too soon: it is irrelevant once the work of painting has been done and presumptuous if this work has not yet begun.

David Pagel

Judy Ledgerwood

Biography
Born 1959, Brazil, Indiana
Lives in Chicago

Education
1984
MFA, The School of The Art Institute
of Chicago, Chicago
1982
BFA, The Art Academy of Cincinnati,
Ohio

One-Person Exhibitions
1992
Robbin Lockett Gallery, Chicago
1991
Richard Green Gallery, Santa Monica,
California
1990
Robbin Lockett Gallery, Chicago
1989
Scott Hanson Gallery, New York
Robbin Lockett Gallery, Chicago
1984
Truman College Gallery, Chicago

Group Exhibitions
1992
*From America's Studio: Drawing New
Conclusions,* Betty Rymer Gallery,
The School of The Art Institute of
Chicago, Chicago
1991
New Acquisitions: The MCA Collects,
Museum of Contemporary Art, Chicago
*The Big Picture / Heroic Gestures:
Recent Abstract Painting,* Palm Beach
Community College Museum of Art,
Lake Worth, Florida
1990
*Harmony and Discord: American
Landscape Today,* Virginia Museum of
Fine Arts, Richmond, Virginia
Drawings, Paula Allen Gallery, New York
Nature, Nature, Gallery 400, University of
Illinois at Chicago, Chicago
Investigations, MoMing Dance & Arts
Center, Chicago
1989
Art on Paper 1989, Weatherspoon Art
Gallery, University of North Carolina,
Greensboro, North Carolina
Small-scale Work, Scott Hanson Gallery,
New York
The Aesthetics of Black, Gallery Vienna
Annex, Chicago
Landscape, Betsy Rosenfield Gallery,
Chicago
Group Exhibition, Robbin Lockett
Gallery, Chicago
1988
Latitudes, Aspen Art Museum, Aspen,
Colorado
Drawings, Robbin Lockett Gallery,
Chicago

Artists See Nature, College of DuPage
Arts Center Gallery, Glen Ellyn, Illinois
Metaphor and Atmosphere, St. Louis
Gallery of Contemporary Art, St. Louis,
Missouri
Individuals II, Compass Rose Gallery,
Chicago
Group Exhibition, Feature, Chicago
Pamela Golden, Judy Ledgerwood,
Robbin Lockett Gallery, Chicago
Group Exhibition, Chidlaw Gallery,
The Art Academy of Cincinnati, Ohio
1987
*The Non-spiritual in Art: Abstract
Painting 1985–???,* 341 West Superior
Street, Chicago
Double Readings, Randolph Street
Gallery, Chicago
1986
Pamela Golden, Judy Ledgerwood,
MoMing Dance & Arts Center, Chicago
1985
The Perfect Couple, C.A.G.E. (Cincinnati
Artists' Group Effort), Cincinnati, Ohio
Wilder Winner's Retrospective, Chidlaw
Gallery, The Art Academy of Cincinnati,
Ohio
1984
Chicago Head, Randolph Street Gallery,
Chicago
Color 84, Oak Park League, Oak Park,
Illinois
Graduate Drawing Exhibition,
The School of The Art Institute of
Chicago, Chicago
1983
Show of Independents, 12th and Elm
Gallery, Cincinnati, Ohio
Group Exhibition, Printers Row on Polk,
The School of The Art Institute of
Chicago, Chicago
1982
Summer Group Show, Toni Birckhead
Gallery, Cincinnati, Ohio
Blood & Night, Chidlaw Gallery, The Art
Academy of Cincinnati, Ohio

Bibliography
Artner, Alan. "Art: Judy Ledgerwood,"
Chicago Tribune (Friday, Jan. 17, 1992,
sec. 7, p 66).
———. "Judy Ledgerwood," *Chicago
Tribune* (Friday, Sept. 21, 1990, sec. 7,
p 66).
Bonesteel, Michael. "Medium Cool: New
Chicago Abstraction," *Art in America*
(Dec., 1987, pp 138–47).
Bulka, Michael. "Individuals II," *New Art
Examiner* (Oct., 1988, p 24).
Cyphers, Peggy. "Judy Ledgerwood,"
Arts Magazine (Dec., 1989, p 96).
Gamble, Allison. "The Myths that Work,"
New Art Examiner (May, 1989, pp 22–5).
Hanson, Henry. "Artworks," *Chicago
Magazine* (Sept., 1990, p 26).

Hansson, Joyce and Elizabeth Ringdon.
"1987: Year in Review," *Chicago Artists'
Coalition Newsletter* (Jan., 1988, pp 4–5).
Hixson, Kathryn. "Chicago in Review,"
Arts Magazine (Dec., 1991, pp 107–8).
———. "Chicago in Review," *Arts
Magazine* (Apr., 1989, p 108).
———. "Cool, Conceptual,
Controversial," *New Art Examiner* (May,
1988, pp 30–3).
Holg, Garrett. "Pamela Golden, Judy
Ledgerwood," *New Art Examiner* (Mar.,
1988, p 49).
Kirshner, Judith Russi. Essay in *Judy
Ledgerwood* (exhibition catalogue).
Richard Green Gallery, Santa Monica,
California: 1991.
McCracken, David. "The Art of Black,"
Chicago Tribune (Friday, June 23, 1989,
sec. 7, p 56).
Nesbitt, Lois E. "Judy Ledgerwood,"
Artforum (Nov., 1989, p 151).
Paradiso, Kathleen. "Judy Ledgerwood,"
New Art Examiner (Jan., 1991, pp 41–2).
Schwan, Gary. "Lannan Museum
reopening as PBCC Museum of Art,"
Palm Beach Post (Sunday, Jan. 13, 1991,
pp 1L–2L).
———. "Show aims to win friends for
museum," *Palm Beach Post* (Sunday,
Jan. 27, 1991, p 2L).
Snodgrass, Susan. "Judy Ledgerwood at
Robbin Lockett," *Artscribe* (Mar. / Apr.,
1991, pp 72–3).

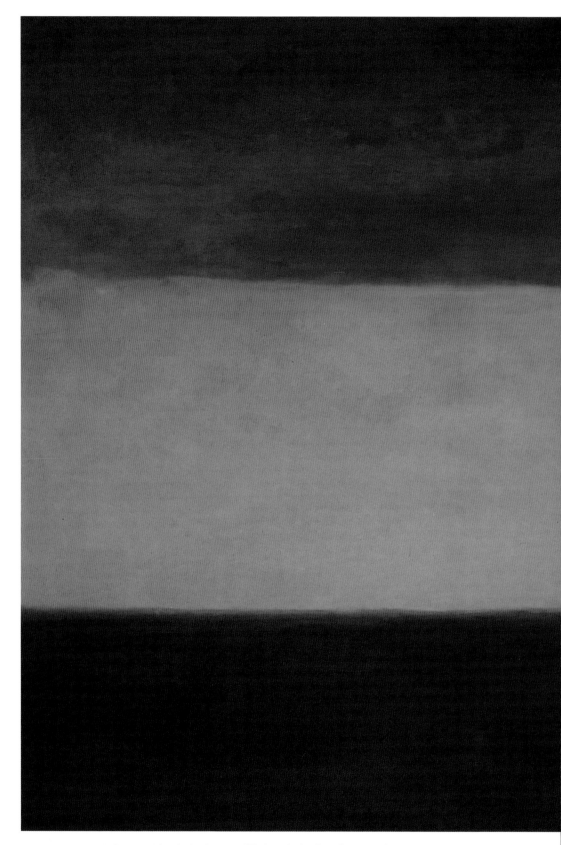

Judy Ledgerwood, *Composition in Apricot and Violet,* 1990, oil and encaustic on canvas,
90 x 120 inches

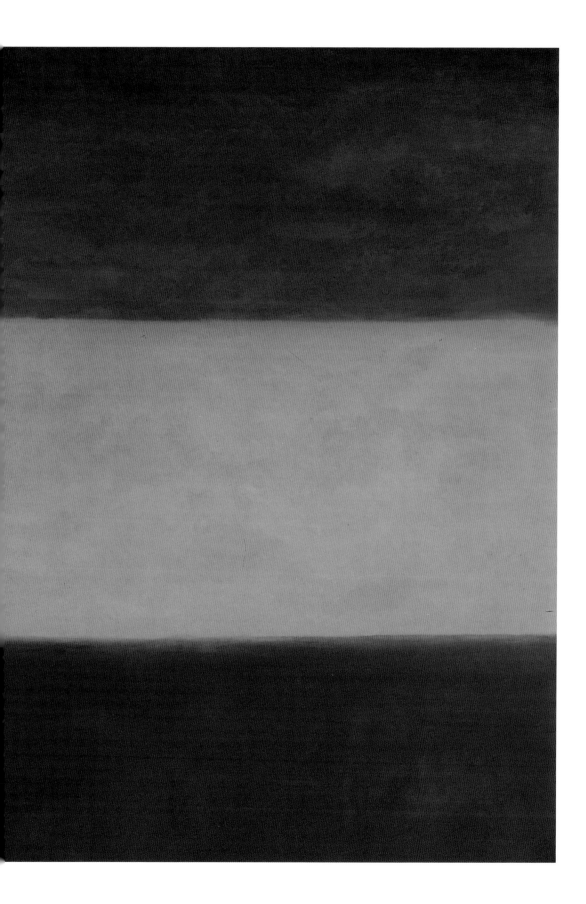

Jim Lutes

Born 1955, Fort Lewis, Washington
Lives in Chicago

Education
1978
BA, Washington State University,
Pullman, Washington
1982
MFA, The School of The Art Institute
of Chicago, Chicago

One-Person Exhibitions
1991
Dart Gallery, Chicago
Ledis Flam Gallery, New York
1990
Temple Gallery, Tyler School of Art,
Philadelphia
FOCI (Forms of Contemporary Illinois)
series, University of Missouri, St. Louis
1989
FOCI, The Illinois State Museum,
Springfield, Illinois; State of Illinois Art
Gallery, Chicago
Michael Kohn Gallery, Los Angeles
1988
Dart Gallery, Chicago
1987
Dart Gallery, Chicago
1986
Dart Gallery, Chicago

Group Exhibitions
1992
Documenta IX, Kassel, Germany
*Face to Face; Self-portraits by Chicago
Artists,* The Cultural Center, Chicago
1991
Spirited Visions, State of Illinois Art
Gallery, Chicago
Distorted Figuration, Evanston Art
Center, Evanston, Illinois
Human, Suburban Fine Arts Center,
Highland Park, Illinois
1990
Ponton, Temse, Belgium
1989
*Chicago Artists in the European
Tradition,* Museum of Contemporary Art,
Chicago
Group Show, Chicago International Art
Exposition, Dart Gallery, Chicago
Encore: Celebrating 50 Years,
The Contemporary Arts Center,
Cincinnati, Ohio
1988
Awards in the Visual Arts 7, Los Angeles
County Museum of Art, Los Angeles;
Carnegie-Mellon University Art Gallery,
Pittsburgh, Pennsylvania; Virginia
Museum of Fine Arts, Richmond, Virginia
Group Show, Chicago International Art
Exposition, Dart Gallery, Chicago
Art and Democracy, Group Material, DIA
Foundation, New York

1987
Biennial Exhibition, Whitney Museum of
American Art, New York
*Surfaces: Two Decades of Painting in
Chicago,* Terra Museum of American Art,
Chicago
Home Front, Randolph Street Gallery,
Chicago
1986
Recent Art From Chicago, Artists Space,
New York
1985
Viewpoints: Doug Argue/Jim Lutes,
Walker Art Center, Minneapolis
A Chicago Souvenir, Dart Gallery,
Chicago
1984–86
39th Corcoran Biennial, Corcoran
Gallery of Art, Washington, D.C.
1984
Chicago 1984: Artists to Watch, Dart
Gallery, Chicago
New Talent, Hal Bromm Gallery,
New York
Chicago and Vicinity, The Art Institute of
Chicago, Chicago
1983
Fantastic Visions, Hyde Park Art Center,
Chicago
Emerging, The Renaissance Society at
The University of Chicago, Chicago
Jim Lutes/Jin Soo Kim, Randolph Street
Gallery, Chicago
Chicago Scene, Mandeville Art Gallery,
University of California at San Diego,
La Jolla, California
1978
Off the Wall, Gallery II, Pullman,
Washington
1977
Pedestrian Art, Pullman, Washington

Bibliography

Adrian, Dennis. "Two Decades of
Painting in Chicago," *New Art Examiner*
(Dec., 1987, pp 26–9).
Bonesteel, Michael. "Report from the
Midwest: 39th Corcoran Biennial:
The Death Knell of Regionalism?,"
Art in America (Oct., 1985, pp 31–7).
Bulka, Michael. "Jim Lutes," *New Art
Examiner* (Mar., 1991, p 34).
Curtis, Cathy. "Jim Lutes," *Los Angeles
Times* (Friday, Aug. 4, 1989, p 16).
Elsasser, Glen. "D.C. exhibit mines art of
Midwest to spotlight a talented
American region," *Chicago Tribune*
(Sunday, Feb. 24, 1985, pp 24–5).
Hixson, Kathryn. "Chicago in Review,"
Arts Magazine (Apr., 1991, pp 107–8).
———. "Jim Lutes," *Arts Magazine* (Dec.,
1988, p 91).
Horrigan, Bill. "Catharsis vs. Anecdote,"
Artpaper (Jan., 1986, p 13).

McCormick, Carlo. "Jim Lutes: Fat
Chances," *Artforum* (Dec., 1988, pp 100–3).
Neff, Eileen. "Jim Lutes," *Artforum* (Dec.,
1990, p 143).
Pagel, David. "Art Pick of the Week:
Jim Lutes," *Los Angeles Times* (Friday,
Aug. 18, 1989, p 23).
Riddle, Mason. "Doug Argue, Jim
Lutes," *New Art Examiner* (Apr., 1986,
p 65).
Snodgrass, Susan. "Jim Lutes,"
Dialogue (May/June, 1991, pp 20–1).
Taylor, Sue. "Jim Lutes," *Art in America*
(Apr., 1990, p 272).

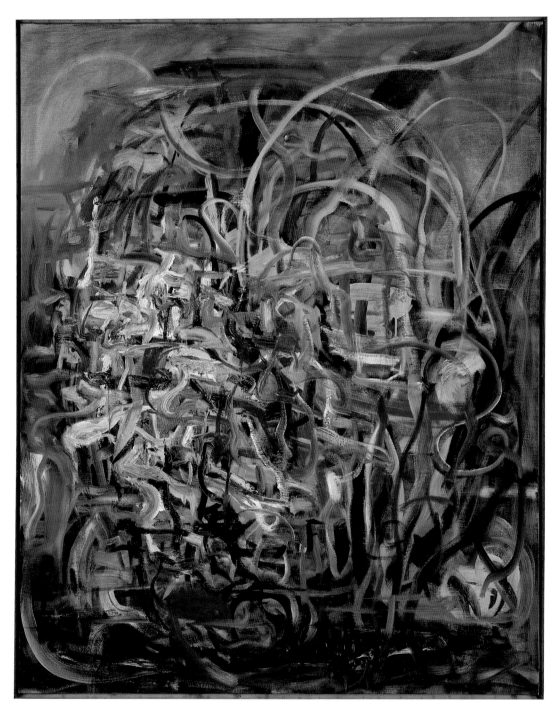

Jim Lutes, *Wizened,* 1992, oil on linen, 60 x 48 inches

Kay Rosen

Born in Corpus Christi, Texas
Lives in Gary, Indiana

Education
1969
BA— Linguistics, Spanish, and French
Newcomb College of Tulane University,
New Orleans, Louisiana
1970
MA— Linguistics, Spanish
Northwestern University, Evanston,
Illinois

One-Person Exhibitions
1992
Feature, New York
1991
Shoshana Wayne Gallery, Santa Monica,
California
Shedhalle, Zurich, Switzerland
Insam/Gleicher Gallery, Chicago
1990
Feature, New York
Victoria Miro Gallery, London
Witte de With Center for Contemporary
Art, Rotterdam
1989
Feature, New York
1988
Feature, New York
Feature, Chicago
1987
Feature, Chicago
1986
University Gallery of Fine Arts, Ohio
State University, Columbus, Ohio
Depree Art Gallery, Hope College,
Holland, Michigan
1984
Broadway Window, The New Museum of
Contemporary Art, New York
Feature, Chicago
1983
Bertha Urdang Gallery, New York
1981
Bertha Urdang Gallery, New York
1980
Franklin Furnace, New York
1979
Bertha Urdang Gallery, New York

Group Exhibitions
1992
*Project with Michael Jenkins and Steven
Evans,* Andrea Rosen Gallery, New York
Tattoo Collection, Air de Paris,
Nice, France
Is it a Boy or is it a Girl?, Real Art Ways,
Hartford, Connecticut
Jack Pierson, Kay Rosen, Nicholas Rule,
Trans avant-garde Gallery,
San Francisco
1991
At the End of the Day, Randy Alexander
Gallery, New York

The Painted Word, Beth Urdang Fine Art,
Boston
*Candy Ass Carnival (When Good Things
Happen to Loozers),* Stux Gallery,
New York
*Just What Is It That Makes Today's
Homes So Different, So Appealing?,*
Hyde Collection, Great Falls, New York
Awards in the Visual Arts 10, Hirshhorn
Museum, Washington, D.C.;
Albuquerque Museum, New Mexico;
Toledo Museum of Art, Toledo, Ohio
A New Low, Claudio Botello Gallery,
Turin, Italy
Nine is a Four-letter Word,
(A Letterpress Project), Key Gallery,
Richmond, Virginia
Crude Thinking, MWMWM Gallery,
Chicago
Lists, C.A.G.E. (Cincinnati Artists' Group
Effort), Cincinnati, Ohio
*Something Pithier and More
Psychological,* Simon Watson Gallery,
New York, Meyers/Bloom Gallery,
Los Angeles
To Wit, Rosa Esman Gallery, New York
Directly On and Off the Wall, Palm
Beach Community College Museum of
Art, Palm Beach, Florida
Women's Work, Victoria Miro Gallery,
London
Five Artists, Marta Cervera Gallery,
New York
News as Muse, School 33 Art Center,
Baltimore, Maryland
Artists in Words and #s, Wright State
University Museum of Contemporary Art,
Dayton, Ohio
1990
In the Beginning..., Cleveland Center
for Contemporary Art, Cleveland, Ohio
The Thing Itself, Feature, New York
Figure: See Feign, Jonathan Borofsky,
Kay Rosen, Kevin Wolff, Center for
Contemporary Art, Chicago
*Work on Paper, An Invitational
Exhibition,* Paula Allen Gallery, New York
*Word as Image: American Art 1960–
1990,* The Milwaukee Art Museum;
Oklahoma City Arts Museum, Oklahoma;
Contemporary Arts Museum, Houston,
Texas
Art Against AIDS—On the Road (outdoor
placards on 50 Chicago Transit Authority
buses), Chicago
Five Installation Artists, Dart Gallery,
Chicago
Broken Lines, Victoria Miro Gallery,
London
Your Message Here (billboard exhibition),
Randolph Street Gallery, Chicago
The Clinic, Simon Watson Gallery,
New York

Looking For Trouble, XS Gallery,
Carson City, Nevada
1989
AIDS: A Time Line, 1979–1990 (a project
by Group Material), Matrix Program at
University Museum, University of
California, Berkeley; Wadsworth
Atheneum, Hartford, Connecticut; 1991
Biennial Exhibition, Whitney Museum of
American Art, New York
Dorothy, Center for Contemporary Art,
Chicago
Romancing the Stone, Feature,
New York
Problems with Reading Rereading,
Rhona Hoffman Gallery, Chicago
The Center Show, The Lesbian and Gay
Community Services Center, New York
1988
From Right to Left, Churchman
Fehsenfeld Gallery, Indianapolis, Indiana
Contention, New Langton Arts,
San Francisco
Brave and Cruel, Randolph Street
Gallery, Chicago
Information As Ornament, Feature,
Chicago
Drawings, Robbin Lockett Gallery,
Chicago
Plato's Cave, Greathouse Gallery,
New York
Cartoon Like, MoMing Dance & Arts
Center, Chicago
Text Does Not Explain..., Stux Gallery,
Boston
*The Language of Form, The Form of
Language,* Rosa Esman Gallery,
New York
Romantic Distance, Jeffrey Neal Gallery,
New York
1987
Signs of Intelligent Life, Greathouse
Gallery, New York
New Chicago, Tangeman Fine Arts
Gallery, University of Cincinnati, Ohio
Group Exhibition, Jan Baum Gallery,
Los Angeles
Wet Paint, Robbin Lockett Gallery,
Chicago
Knew, Feature, Chicago
Group Exhibition, American Fine Arts,
New York
(Dark Laughter), Randolph Street
Gallery, Chicago
*The Non-spiritual in Art: Abstract
Painting 1985–???,* Chicago
Nature, Feature, Chicago
1986
Invitational Show of Women Artists,
Feature, Chicago
Cryptic Languages, Washington Project
for the Arts, Washington, D.C.
Non-spiritual America, CEPA Gallery,
Buffalo, New York
Promises, Promises, Feature, Chicago

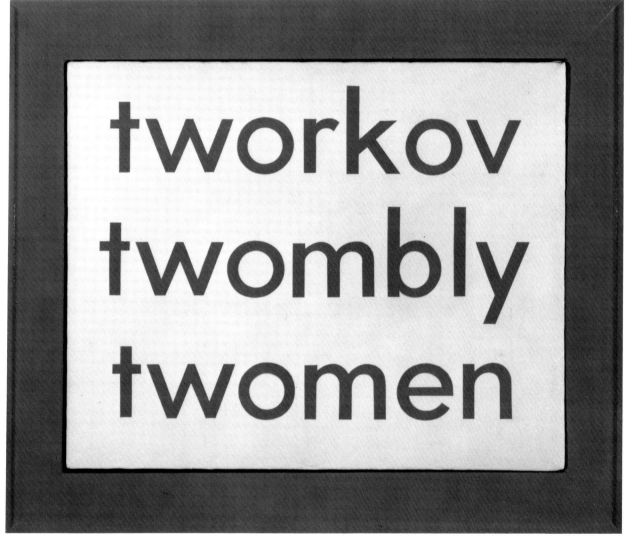

Kay Rosen, *Six,* 1986–87, enamel sign paint on canvas, 11 x 14 inches

1985
National Artists Book Exhibit, Fifth Conference of Artists Organizations, Houston, Texas
Critical Messages: The Use of Public Media for Political Art by Women, Artemisia, Chicago
Messages From the Interior, N.A.M.E. Gallery, Chicago
Invitational Show, Feature and Rhona Hoffman Gallery, Chicago
1984
Indiana Influence, Inaugural Exhibition, Fort Wayne Museum of Art, Fort Wayne, Indiana
1982
Artists' Tribute to Bertha Urdang, Israel Museum, Jerusalem
Tracking, Tracing, Marking, Pacing, Pratt Manhattan Gallery, New York; Sherman Gallery, Ohio State University, Columbus, Ohio; University of Richmond, Richmond, Virginia; Washington Project for the Arts, Washington, D.C.
1981
Bookworks: New Approaches to Artists' Books, organized by Franklin Furnace, New York
Ikons/Logos: Word as Image, Alternative Museum, New York
1980
New Dimensions: Time, Museum of Contemporary Art, Chicago

Bibliography

Artner, Alan. "Kay Rosen at Insam/Gleicher Gallery," *Chicago Tribune* (Friday, Mar. 1, 1991, sec. 7, p 38).
———. "Review," *Chicago Tribune* (Thursday, Mar. 17, 1988, sec. 5, p 14).
———. "Review," *Chicago Tribune* (Thursday, Mar. 12, 1987, sec. 5, p 9F).
Bowman, Russell. Essay in *Text As Image: American Art 1960–1990* (exhibition catalogue). Milwaukee Art Museum, Milwaukee, Wisconsin: 1990.
Bright, Deborah. "New Dimensions: Time," *New Art Examiner* (Apr., 1980, p 23).
Browning, Robert H. Essay in *Ikons/Logos: Word as Image* (exhibition catalogue). Alternative Museum, New York: 1981.
Brunetti, John. "Kay Rosen," *New Art Examiner* (May, 1991, p 44).
Collins, Tricia and Richard Milazzo. Essay in *A New Low* (exhibition catalogue). Claudio Botello Gallery, New York: 1991.
———. Essay in *Non-spiritual America* (exhibition catalogue). CEPA Gallery, Buffalo, New York: 1987.
Frank, Peter. Essay in *Indiana Influence* (exhibition catalogue). Fort Wayne Museum of Art, Fort Wayne, Indiana: 1984.
Gillick, Liam. "Kay Rosen at Victoria Miro," *Artscribe* (Jan./Feb., 1991, p 76).
Hanson, Henry. *Chicago Magazine* (Apr., 1991, pp 30–1).
Hixson, Kathryn. Essay in *Awards in the Visual Arts 10* (exhibition catalogue). Southeastern Center for Contemporary Art, Winston-Salem, North Carolina: 1991.
———. "Chicago in Review," *Arts Magazine* (May, 1991, p 106).
———. "Chicago in Review: 'Dorothy'," *Arts Magazine* (Nov., 1989 pp 109–110).
———. Essay in *Figure: See Feign* (exhibition catalogue). Center for Contemporary Art, Chicago: 1990.
Hoffberg, Judith A. "Lines On Lines by Kay Rosen," *Umbrella* (Mar., 1983, p 50).
Johnson, Ken. "The Painted Word," *Vogue* (Aug., 1991, pp 142–8).
Kandel, Susan. "Kay Rosen at Shoshana Wayne Gallery," *Los Angeles Times* (Friday, Dec. 13, 1991, p 24).
Kirshner, Judith Russi. "read read rosens," *Artforum* (Dec., 1990, pp 91–5).
Maginnis, Kevin and David Robbins. Essays in *Information as Ornament* (exhibition catalogue). Feature, Chicago: 1988.
Mahoney, Robert. "New York in Review," *Arts Magazine* (Jan., 1991, p 104).
Morgan, Stuart. "Kay Rosen at Victoria Miro," *Time Out* (London, Sept. 26–Oct. 3, 1990, p 57).
Palmer, Laurie. "Problems With Reading Rereading," *Artforum* (Sept., 1989, p 84).
Porges, Timothy. Essay in *Looking for Trouble* (exhibition catalogue). XS Gallery, Carson City, Nevada: 1990.
Robinson, Walter. "State of the Art: Young, Gifted and Affordable," *Metropolitan Home* (Nov., 1987, p 58).
Rosenberg, Barry. Essay in *Artists in Words and #s* (exhibition catalogue). Wright State University Museum of Contemporary Art, Dayton, Ohio: 1991.
Saliga, Pauline A. Essay in *New Dimensions: Time* (exhibition catalogue). Museum of Contemporary Art, Chicago: 1980.
Scanlan, Joseph. "Problems With Reading Rereading," *Artscribe* (Sept./Oct., 1989, p 84–5).
———. "Kay Rosen," *Dialogue* (July/Aug., 1988, pp 33–4).
Schwartz, Ellen. Essay in *Tracking, Tracing, Marking, Pacing* (exhibition catalogue). Pratt Manhattan Gallery, New York: 1982.
Shaneff, Angela. "Kay Rosen Draws on Words," *Indiana Arts Commission Quarterly* (Summer, 1988, p 4).
Smith, Roberta. "The Group Show as Crystal Ball," *The New York Times* (Friday, July 6, 1990, pp C1, C 23).
Spector, Buzz. "Kay Rosen," *Artforum* (May, 1988, p 154).
Thomson, Mark. "Kay Rosen, Ed Ruscha," *Art Monthly* (London, Nov., 1990, pp 22–3).
Vacca, Linnea B. "Words, Words, Words," *Arts Indiana* (May, 1991, pp 24–7).
Wittig, Rob. "Kay Rosen," *Art in America* (Jan., 1989, p 157).

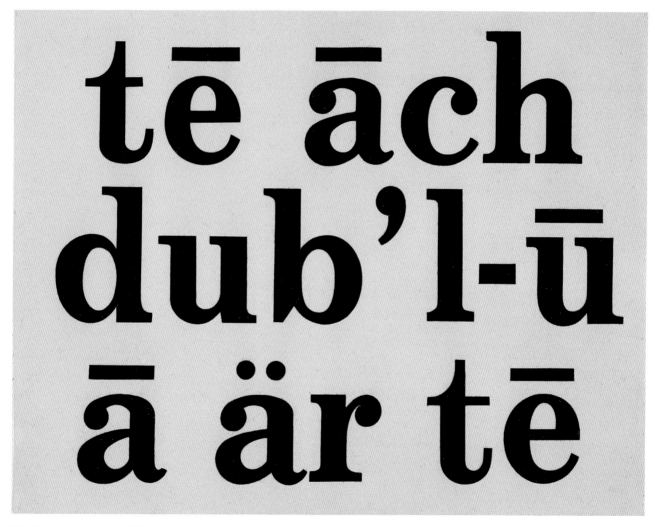

Kay Rosen, *t-h-w-a-r-t,* 1989, sign paint on canvas, 11 x 14 inches

Kevin Wolff

Born 1955, Buffalo, New York
Lives in Chicago

Education
1977
BFA, Rochester Institute of Technology,
Rochester, New York
1980
MFA, The School of The Art Institute of
Chicago, Chicago

One-Person Exhibitions
1991
Feature, New York
1990
Feature, New York
1988
Washington Square Windows, Grey Art
Gallery, New York University, New York
1987
Feature, Chicago
1986
Sexual Portraits, Feature, Chicago
1985
Redmen, Hallwalls, Buffalo, New York

Group Exhibitions
1991
Office Party, Feature, New York
Louder, Gallery 400, University of Illinois
at Chicago, Chicago
Anti-Nihilism, (curated by Kevin Wolff),
N.A.M.E. Gallery, Chicago
1990
Figure: See Feign, Jonathan Borofsky,
Kay Rosen, Kevin Wolff, Center for
Contemporary Art, Chicago
1989
Office Party, Feature, New York
Dorothy, Center for Contemporary Art,
Chicago
Romancing the Stone, Feature,
New York
1988
Against Nature, L.A.C.E. (Los Angeles
Contemporary Exhibitions), Los Angeles
Near Miss, Feature, Chicago
Bess Cutler Gallery, New York
1987
Signs of Intelligent Life, Greathouse
Gallery, New York
Knew, Feature, Chicago
*The Other Man: Alternative
Representations of Masculinity,* The New
Museum of Contemporary Art, New York
Head Sex, Feature, Chicago
Confrontation, Hyde Park Art Center,
Chicago
Floating Values, Hallwalls, Buffalo,
New York
1986
Promises, Promises, Feature, Chicago;
C.A.G.E. (Cincinnati Artists' Group
Effort), Cincinnati, Ohio

1985
Unknown Chicago Painters, Gallery 400,
University of Illinois at Chicago, Chicago
*81st Exhibition by Artists of Chicago and
Vicinity,* The Art Institute of Chicago,
Chicago
Shadow Show, N.A.M.E. Gallery,
Chicago
1984
Head Show, Randolph Street Gallery,
Chicago
Outdoor Installations, Randolph Street
Gallery, Chicago
1980
Fellowship Exhibition, The School of The
Art Institute of Chicago, Chicago
1979
8 x 10 Show, West Hubbard Street
Gallery, Chicago
1976
Finger Lakes Exhibition, Rochester
Memorial Art Gallery, Rochester,
New York

Bibliography

Artner, Alan. "The subject is sex and the
style is cerebral," *Chicago Tribune*
(Thursday, Aug. 6, 1987, sec. 5, p 12).
Bonesteel, Michael. "Kevin Wolff," *Art in
America* (Sept., 1987, p 193).
Dector, Joshua. "New York in Review,"
Arts Magazine (Apr., 1990, pp 106–7).
Hirsch, David. "Living Figures," *New
York Native* (Jan. 29, 1990, p 33).
Hixson, Kathryn. "Kevin Wolff," *New Art
Examiner* (Sept., 1986, p 50).
Leonhart, Mark Michael. "'Head Sex':
an orgy of comprehension," *Windy City
Times* (Thursday, July 23, 1987, pp
19–20).
McCracken, David. "New works stand
on their own hands and feet," *Chicago
Tribune* (Friday, July 27, 1990, sec. 7,
p 69).
Scanlan, Joseph. "Dorothy," *New Art
Examiner* (Nov., 1989, pp 40–1).
Schwartsman, Alan. "Goings on About
Town," *The New Yorker* (Jan. 29, 1990,
p 14).
Spiegel, Judith. "Brave and Troubled
Voices," *Artweek* (Saturday, Feb. 4, 1989,
p 1).

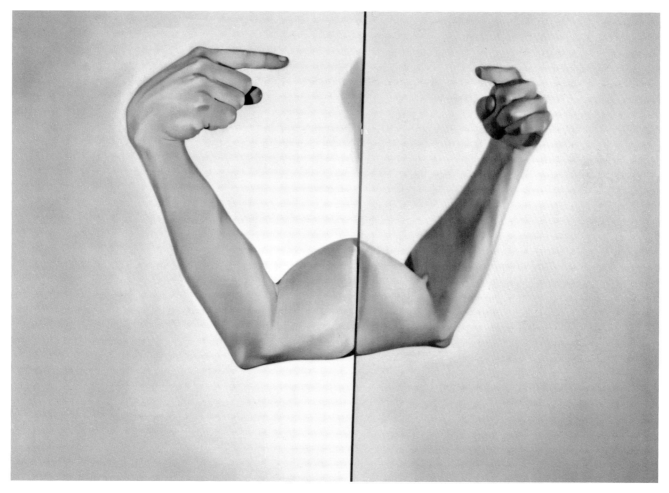

Kevin Wolff, *Pointing Arm,* 1990, acrylic on canvas, 36 x 52 inches

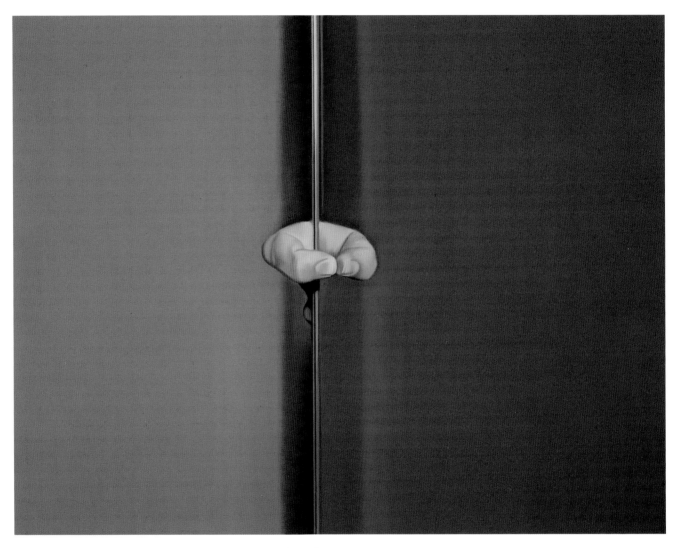

Kevin Wolff, *Curled Finger,* 1992, acrylic on canvas, 34 x 44 inches

Exhibition List

1.
Judy Ledgerwood
Composition in Apricot and Violet, 1990
Oil and encaustic on canvas
90 x 120 inches
Lent by the artist, courtesy of
Robbin Lockett Gallery, Chicago

2.
Judy Ledgerwood
Red Pine, 1990
Oil and encaustic on canvas
90 x 144 inches
Lent by the artist, courtesy of
Robbin Lockett Gallery, Chicago

3.
Jim Lutes
Hopeful Board, 1991
Acrylic on linen
36 x 48 inches
Lent by the artist, courtesy of
Dart Gallery, Chicago

4.
Jim Lutes
Crib Return, 1992
Oil on linen
60 x 72 inches
Lent by the artist, courtesy of
Dart Gallery, Chicago

5.
Jim Lutes
Road Conditions, 1992
Oil on linen
72 x 60 inches
Lent by the artist, courtesy of
Dart Gallery, Chicago

6.
Jim Lutes
Wizened, 1992
Oil on linen
60 x 48 inches
Lent by the artist, courtesy of
Dart Gallery, Chicago

7.
Kay Rosen
Six, 1986–87
Enamel sign paint on canvas
11 x 14 inches
Lent by Mr. and Mrs. Thomas H.
Dittmer, Chicago

8.
Kay Rosen
*The Ed Paintings: Surprise, Technical
Difficulties, Sp-spit it out, Blanks
(diptych)*, and *Ex-Ed,* 1988
Enamel sign paint on canvas
6 panels, 30 x 22 each
Lent by the artist, courtesy of
Feature, New York

9.
Kay Rosen
Tree Lined Street, 1988–89
Enamel sign paint on canvas
16 x 10 inches
Lent by Anstiss Drake and Ron
Krueck, Chicago

10.
Kay Rosen
ditto, mimic, xerox, 1989
Enamel sign paint on canvas
15 x 15 inches
Lent by Steve Marton, Chicago

11.
Kay Rosen
t-h-w-a-r-t, 1989
Enamel sign paint on canvas
11 x 14 inches
Lent by private collection, East
Hampton, New York

12.
Kay Rosen
feud, 1990
Enamel sign paint on canvas
7³⁄₈ x 17³⁄₈ inches
Lent by the artist, courtesy of
Feature, New York

13.
Kay Rosen
you lie through your teeth, 1990
Enamel sign paint on canvas
7³⁄₄ x 19 inches
Lent by the artist, courtesy of
Feature, New York

14.
Kevin Wolff
Pointing Arm, 1990
Acrylic on canvas
36 x 52 inches
Lent by The Progressive Corporation,
Cleveland, Ohio

15.
Kevin Wolff
Arm with Hole, 1991
Acrylic on canvas
42 x 80 inches
Lent by the Neuberger and Berman
Collection, New York

16.
Kevin Wolff
Gang Symbol, 1992
Acrylic on canvas
42 x 61 inches
Lent by the artist, courtesy of
Feature, New York

17.
Kevin Wolff
Curled Finger, 1992
Acrylic on canvas
34 x 44 inches
Lent by the artist, courtesy of
Feature, New York

Installation view, left to right: Kevin Wolff, *Arm with Hole,* 1991; Kay Rosen, *t-h-w-a-r-t,* 1989; Judy Ledgerwood, *Composition in Apricot and Violet,* 1990

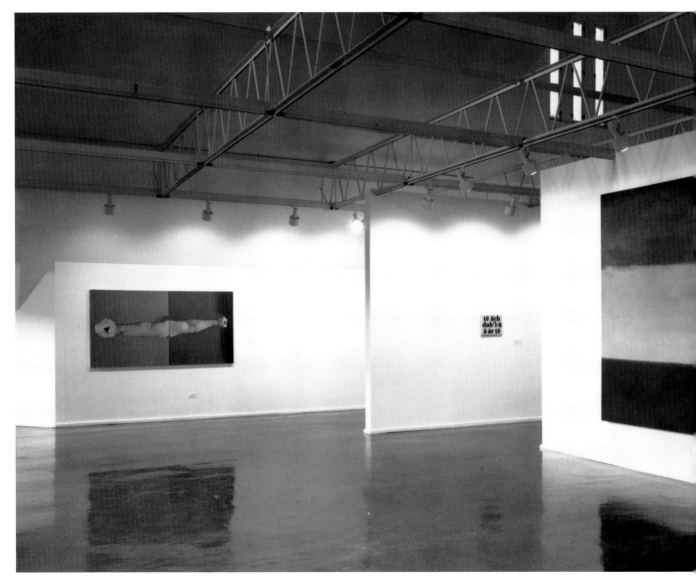